1 Love Leopard

I Love Leopard

The Little Book of Leopard Print

Emma Bastow

HARPER
DESIGN

An Imprint of HarperCollinsPublishers

Contents

Introduction

Welcome, leopard-lovers, to this totally roarsome book, full of feline fun, frolics, and a huge dose of fabulousness. Whether you're curious about the evolution of leopard-print fashion, keen to learn a few leopard-themed jokes, or planning a party fit for a spot-obsessed friend, there's a chapter here for you.

Let *Leopard Fashion* (see pages 8–37) take you on a journey from the age of the silver screen, through punk via glam rock, to today's influencer-obsessed fast-fashion culture. Learn how the trend for wearing real fur was overtaken by luscious silks and expensive gowns created to showcase these spotted designs, and how leopard print has constantly evolved and adapted to suit the fashions of the day.

Get creative with *Leopard Makes* (see pages 38–65) and wow your friends with leopard-print cakes and cookies. Kids will love the hide-and-seek bread (especially if it's served slathered in chocolate spread—yum) and the spotted jello, and the easy-peasy leopard face paint will make fancy dress parties a doddle for both kids and adults. And for a touch of class in a glass, try out the spot painting technique included in this chapter—so simple but oh-so-leopard.

For facts, fiction, and philosophy, look no further than *Leopard Lives* (see pages 66–99). Here you will read about the majestic snow leopard, find out how to analyze your leopard dreams, and perhaps even learn a proverb or two. Heard about the leopard that lost its spots? Or the unusual strawberry-colored leopard that's been sighted in South Africa? Read on to discover more about these fascinating and surprising creatures.

Leopard Fun (see pages 100–127) is packed with ideas, inspiration, and ideology. Did you know about the leopard-print house? Believe it or not, it really does exist. Want to know which celebrity includes a leopard-print rug in their riders? Or just how many Instagram posts have been tagged with the hashtag "leopard"? It's all here, along with crazy quotes, jolly jokes, and a sackful of silliness.

So my fellow feline friends, let's delve into this world of leopard-print madness and celebrate all that is great about these beautiful animals. Enjoy, and remember to always keep it leopard.

Leopard Fashion

Dress Like a Leopard

Leopard print has come a long way since the hide of these beautiful animals was adopted by African tribal leaders to symbolize power, and draped over the shoulders of kings to show off their hunting prowess. Thankfully the twentieth century saw the advent of synthetic leopard-print fabric, and so the obsession began.

The first leopard-print garment appeared on the runway in 1947 and it quickly earned a cult following. Popularized by everyone from '40s screen sirens to '80s punks, the print has undergone numerous incarnations in the fashion world and has established a reputation for being daring, bold, and rebellious.

Today pretty much every fashion store will stock at least one leopard-print item at any one time, and although the fashion peaks and wanes, the print never truly vanishes—reappearing as a must-have every few seasons. From bags, jewelry, and scarves to nail art, underwear, nightwear, and everything in between, virtually every item of clothing and fashion accessory is available in this vibrant design.

And leopard print is no longer confined to the traditional cream–brown and yellow–orange color scheme. Is bright pink your thing? There's a leopard-print design out there for you. Lover of bright rainbow patterns? Yep, rainbow leopard print is a thing. But why did we start wearing leopard spots in the first place? And how has this print endured for so many decades? Read on to find out.

DID YOU KNOW ...?

Henry VIII was fashion-forward

Leopard skin was the height of fashion among the British nobility in the fifteenth and sixteenth centuries, and Henry VIII and his courtiers wore velvet gowns adorned with animal fur to display their wealth. Commoners, however, were banned from wearing fur as well as the color purple.

Leopard print first appeared on the runway in 1947

Leopard-print fabric—rather than fur—made its runway debut in 1947 thanks to Christian Dior, whose Spring/Summer collection that year featured a silk-chiffon "Jungle" print evening gown and day dress.

Leopard-Print Evolution

1940

Leopard print plays a big part in Christian Dior's New Look styles, as screen sirens and pin-ups are photographed wearing daring leopard corsets and lingerie. The print takes on new meaning, being seen as exotic and erotic.

1920

This stylish and sexy fabric becomes popular among rich and famous women during the Jazz Age, as modeled by Joan Crawford.

1930

1960

First Lady Jackie Kennedy shows fierce dedication to the print, Audrey Hepburn models a leopard-print pillbox hat in *Charade*, and Mrs Robinson wears a leopard-print coat and matching underwear in *The Graduate*. Ooh la la.

Fur hits the runway as the latest must-have fabric, and, sadly, leopard hide comes into fashion in a big way among the super-rich.

1950

1970

Glam rock, punk, and
spandex bodysuits—
the '70s see leopard
print explode into pop
culture, as sported
most famously by
Sid Vicious and
Debbie Harry.

As fashion becomes all about
power-dressing, Diane Von
Furstenberg chooses the design
for her iconic wrap dress, taking
leopard print from the fringes to
the mainstream.

1980

2000

Influencers and designers find new ways to use the spots. In 2019 Versace sends a male model down the runway with leopard-print hair and almost causes total internet collapse. One bold enthusiast in Rogers Park, Chicago, paints their house with a leopard-print design (see Chapter 4). We can only imagine what leopard-print creations the future will bring, but one thing is for sure—leopard print is here to stay.

Leopard print hits the mass market in a big way. Everyone from Scary Spice to Kate Moss adopts the spots, and it's all over the high street as animal print sees a massive surge in popularity.

1990

Leopard Goes Mainstream

Diana Vreeland, the legendary fashion editor who took the helm at both *Vogue* and *Harper's Bazaar* during her illustrious career, was largely responsible for bringing leopard print to the masses. Her unwavering commitment to the design included hailing it as the Next Big Thing after a young Yves Saint Laurent showcased leopard designs, a piece she no doubt wrote in her leopard-print-adorned office. Diana's leopard-loving influence reached far and wide, from music—Joey Ramone of the Ramones is said to have worn leopard bracelets in her honor—to Pop Art. Without her, who knows if leopard print would be the enduring force it is today.

I've never met a leopard print

I didn't like.

Diana Vreeland 1903–1989
EDITOR-IN-CHIEF VOGUE AND HARPER'S BAZAAR

How Do You Wear Yours?

Subtle and muted or bright and bold? Whether you're an in-your-face leopard-clad goddess or prefer a little more sophistication with just the flash of a leopard-print scarf or purse, see pages 21–23 to learn what your leopard style says about you.

The classic leopard

You're a puritan—only the classic black-and-brown combo works for you, and you wear it with style. Smart, sophisticated, and in control, your wardrobe oozes class and contains timeless pieces that you wear season after season.

The colorful leopard

You like your leopard prints BRIGHT. Pinks, purples, greens, yellows—anything but beige. You were ahead of the curve when rose-gold animal prints hit the high street and love nothing more than a leopard-print color clash to see you from day to eveningwear.

CONTINUED

The on-trend leopard

You follow the fashion pages closely and are always first in line for the latest leopard-print item. This season's leopard skirt a sellout? No problem, you were on the waiting list three seasons ago and bought one in every colorway.

The leopard accessorizer

Is the all-over leopard look too much for you? Do you keep it classy with black and muted tones and then go wild with your add-on items? You're a textbook accessorizer. From scarfs, shoes, and notebooks to cell phone covers, you love to accent with leopard print.

The experimental leopard

A lover of pushing the boundaries, your leopard style is fierce. Neons are mixed with animal prints in a mish-mash that shouldn't work but somehow you manage to pull off. Always. For you, leopard is most definitely a neutral.

"To wear leopard you must have a kind of femininity which is a little bit sophisticated. If you are fair and sweet, don't wear it."

—The Little Dictionary of Fashion
CHRISTIAN DIOR

Faux fur has been embraced by African tribespeople

African tribal leaders, who traditionally wear leopard hide, have recently embraced faux fur in an effort to reduce the poaching of these beautiful animals.

Leading Ladies Love Leopard

Trashy, sophisticated, brash, regal: whatever the look, leading ladies love leopard print! From the moment that Anne Bancroft burst (almost literally) into cinemas in the 1968 film *The Graduate*, seducing a young Dustin Hoffman in matching leopard-print coat and underwear, the big and small screen has been awash with leopard-clad female leads.

The 1990s saw two very different characters bringing leopard print to the forefront. Patricia Arquette's tighter-than-tight pink leopard leggings in Quentin Tarantino's 1993 film *True Romance* had a fan base all of their own, while in 1999's *The Talented Mr. Ripley*, Gwyneth Paltrow sported the ever-classy leopard-print pillbox hat and coat ensemble.

World-dominating girl group the Spice Girls zigazig ah-ed onto our screens in *Spice World: The Movie* in 1997 and sales of leopard-print catsuits went through the roof.

One designer's dedication to faux fur

In 1968, fashion designer Rudi Gernreich created a whole collection using faux animal print as a protest against the trend for wearing real fur.

Leopard-print coats are (almost) always in fashion

Having graced the runways at fashion shows since the 1920s, it's no real surprise that in 2018 the most talked-about item of the Autumn/Winter season was Victoria Beckham's leopard-print coat. Based on a Venetian upholstery fabric and reworked as chenille jacquard, it would set the wearer back a cool $3,110.

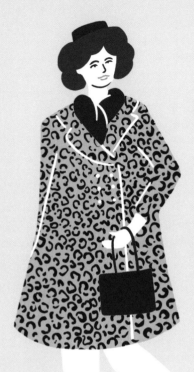

Leopard
Meets
Politics

Fashion icon Jackie Kennedy single-handedly made leopard fur a must-have item in every fashionable lady's repertoire in the 1960s. Michelle Obama took the trend one step further by attending a White House Halloween party dressed as a leopard, showing true dedication to the cause.

In October 2002, future British Prime Minister Theresa May caused quite a stir when she delivered a speech at the Conservative Party Conference wearing leopard-print kitten heels. Such was her dedication to leopard-print footwear that she stepped out in no fewer than five different versions during her time as British Prime Minister—from ballet pumps to stilettos to rubber boots. She also chose leopard-print shoes for her Downing Street exit speech in 2019.

And Clementine Churchill was regularly seen on the campaign trail with Winston in the 1940s wearing her signature leopard-print coat and head scarf.

A leopard's spots are called rosettes

A leopard's spots are called rosettes because their shape resembles a rose. Usually dark brown, the rosettes create a dramatic pattern against the otherwise lighter-colored fur that designers like to adopt for clothing and accessories.

Leopard print is here to stay

Online fashion retailer ASOS sold 1.3 million animal-print items in 2018, proving that leopard print is more than just a look, it's a way of life.

The Leopard-skin Pillbox Hat

Pillbox hats were invented by milliners in the 1930s and soon became popular among elegant women. Perhaps worn most notably by Audrey Hepburn's character in the 1963 film *Charade*, in 1966 Bob Dylan released an ode to the fashion in his song "Leopard-Skin Pill-Box Hat."

Appearing on the album *Blonde On Blonde*, theories about the meaning of the lyrics vary, from the pillbox hat being a euphemism for birth control pills (newly available in the 1960s) to the song being about model and actress Edie Sedgwick. When asked about the inspiration by *Rolling Stone* magazine, Dylan simply said that he "Mighta seen a picture of one in a department store window," so perhaps it is about a hat after all.

Punk
Leopard

Nothing highlights the versatility of leopard print more than the swerve from runway sophistication to teenage rebellion. Glam rock was on the rise in the 1970s and with it came leopard-print spandex body suits, worn by both men and women.

Later, punk burst onto the scene and leopard style morphed to suit. From torn clothes held together with safety pins to underwear as outerwear, fashion was out to shock the establishment and leopard print was at the heart of the rebellion. Sid Vicious, Debbie Harry, David Bowie, and Patti Smith all adopted the feline print as their signature look, wearing jumpsuits, leggings, and bandanas with abandon.

Know Your Leopard Print

The runways and shopping malls may be awash with animal prints, but how can you tell your leopard from your cheetah? And what does a jaguar print look like anyway? Let this handy guide to the feline family help you identify the real deal.

Leopard print

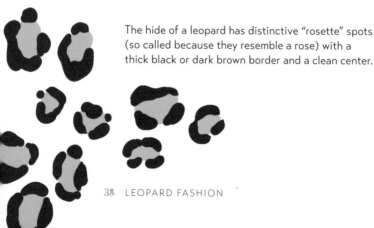

The hide of a leopard has distinctive "rosette" spots (so called because they resemble a rose) with a thick black or dark brown border and a clean center.

Jaguar print

Jaguars also have "rosette" spots but these tend to be larger than a leopard's and have smaller spots within the larger spots.

Cheetah print

Cheetahs have evenly-spaced, solid black spots on a golden-brown background.

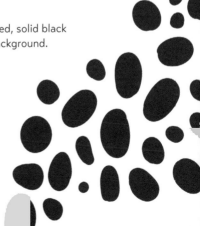

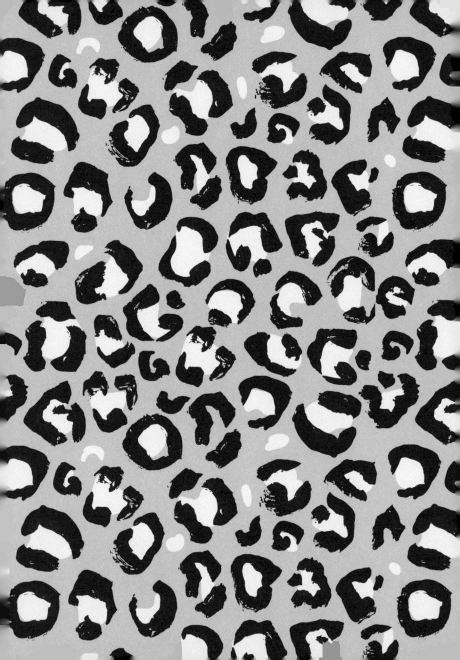

Leopard Makes

Create Like a Leopard

This chapter is all about unleashing your wild side and getting creative. You've worn leopard, now it's time to create leopard. Why not go the whole nine yards and create a leopard-themed afternoon tea with the recipes on the following pages while showing off your leopard-print face and nail-painting skills?

Leopard-print designs may look complicated, but a leopard's spots really are quite easy to replicate. If you take a look at the hide of these beautiful creatures you'll see that the spots are irregular and misshapen. When it comes to reproducing these spots in food or decoration, this irregularity makes it easy to hide any mishaps with a brush, and gives you the freedom to be fairly heavy-handed when working with cookie dough.

So whether you are looking for a leopard-printed cake to present to a spot-loving friend, a simple technique for creating a leopard look for a festival, or hide-and-seek leopard bread to wow the kids, there's a leopard make here for everyone.

Super Simple Leopard-spotted Cake

This technique can be used to create leopard-spotted cakes in any shape and size. I'm giving the recipe for a basic Victoria sponge-style cake but feel free to substitute the batter with your favorite mix and decorate in any way that takes your fancy.

For the cake:

1¾ cups (225g)	**self-rising flour**
2 tsp	**baking powder**
1⅛ cups (225g)	**superfine sugar**
16 tbsp	**unsalted butter**, softened,
(2 sticks/225g)	plus extra for greasing
4	**large eggs**
1 tsp	**ground cinnamon**
5 tsp	**cocoa powder**

For the chocolate buttercream:

3½oz (100g)	**milk chocolate**
4 cups (400g)	**confectioners' sugar**
5 tbsp	**cocoa powder**
14 tbsp (200g)	**unsalted butter**, softened
2 tbsp	**milk**

For decorating:

	Milk and white chocolate chips (optional)

01 Grease and line two 8in (20cm) cake pans. Place the flour, baking powder, sugar, butter, and eggs in a bowl. Mix until pale and fluffy using a handheld electric mixer or stand mixer.

02 Divide the mixture in two. Set one half aside and divide the other half in two again and place in separate bowls.

03 Add the cinnamon and 1 tsp cocoa powder to one bowl and the remaining cocoa powder to the other bowl (you may need to adjust the quantities slightly to achieve the desired color). Whisk briefly to combine. You should now have three bowls of mixture: one uncolored, one light brown, and one dark brown.

04 Place all three mixtures into separate piping bags and cut off the ends. Preheat the oven to 350°F/180°C.

05 Pipe enough of the uncolored cake mixture into both pans to cover the bases. Pick up the piping bag containing the dark brown mixture and pipe three or four circles on top of the uncolored mixture. Swap to the lighter brown mixture and pipe circles directly over the top of the darker circles, then switch back to the darker brown and again pipe circles over the top. Pipe enough of the uncolored mixture into the pan to cover.

06 Repeat this process, alternating the piping bags, with the remaining mixture, aiming to have approximately the same amount of mixture in each pan.

07 Bake for 25 minutes or until golden-brown and springy to the touch. Allow to cool in the cake pans for 5 minutes then turn out onto a wire rack to cool completely before icing.

Meanwhile make the chocolate buttercream.

01 Melt the chocolate in a heatproof bowl over a pan of barely simmering water. Remove the bowl from the pan and leave to cool for 5 minutes.

02 Sieve the confectioners' sugar and cocoa powder into a bowl then add the butter and milk. Mix well using a handheld electric mixer or stand mixer until smooth.

03 Use the buttercream to sandwich the cakes together. Cover the top with the remaining buttercream and decorate with the chocolate chips, if desired.

Leopard-spot Cookies

These impressive cookies may look complicated but they really are quite straightforward. The dough can be frozen at the end of Step 2 (just be sure to fully defrost before moving on to Step 5), so why not make a double batch and have some dough handy for whenever you feel the need to indulge.

4¾ cups (600g)	**all-purpose flour**, sifted
1 tsp	**baking powder**
Pinch of	**salt**
2	**large eggs**, beaten
1 cup (200g)	**superfine sugar**
18 tbsp (250g)	**unsalted butter**, softened
4 tsp	**lemon juice**
1 tsp	**ground cinnamon**
5 tsp	**cocoa powder**

01 Combine the flour, baking powder, and salt in a bowl and set aside. Whisk the eggs with the sugar, butter, and lemon juice using a handheld electric mixer or stand mixer. Gradually add the flour mixture to the egg mixture, folding it in with a wooden spoon after each addition, until the mixture comes together. Form into a soft dough using your hands but take care not to over mix.

02 To achieve the two shades of brown, take approximately one third of the dough and divide it into two parts, one slightly larger than the other. Set the remaining dough aside. Flatten the smaller piece of dough and sprinkle over the cinnamon and 1 teaspoon of the cocoa powder. Knead to combine. Flatten the larger piece of dough, sprinkle over the remaining cocoa powder, and

knead to combine. Wrap all 3 pieces of dough in plastic wrap and refrigerate for 1 hour.

03 Remove the plastic wrap and roll the darker brown dough into a long, narrow cylinder, approximately 2in (5cm) in diameter. Form the lighter brown dough into a cylinder of the same length. Wrap the darker dough strip around the lighter dough cylinder, pressing down the edge to cover. Wrap in plastic wrap and place in the freezer for 10 minutes.

04 Preheat the oven to 350°F/180°C and line a baking sheet with parchment paper. Briefly knead the uncolored dough on a floured work surface and, using a rolling pin, roll out until ¼in (5mm) thick. Remove the dough cylinder from the freezer and cut into ¼in (5mm) rounds. Place the colored dough rounds over the uncolored dough in a pattern that resembles leopard print. Cover with aluminum foil and lightly roll. Remove the foil and cut out 12 rounds using a 2½in (6cm) cookie cutter.

05 Transfer the rounds to the prepared baking sheet using a spatula and bake for 10 minutes until golden. Leave to cool on the baking sheet for a few minutes, then carefully lift onto a wire cooling rack to cool completely.

Leopard Bread

The real beauty of this bread is that it looks like a regular loaf from the outside, only revealing the leopard-print effect when sliced. Serve while still warm, and spread with oodles of hazelnut chocolate spread.

1¼ cups (300ml)	**whole milk**
⅔ cup (150ml)	**water**
6 tbsp (75g)	**butter**, diced, plus extra for greasing
5½ cups (750g)	**strong white bread flour**, plus extra for dusting
2 tsp	**salt**
1½ tsp (7g) sachet	**fast-action dried yeast**
1 tbsp	**superfine sugar**
1 tsp	**ground cinnamon**
5 tsp	**cocoa powder**

01 Grease a 9 x 5in (900g) loaf pan. Heat the milk and water in a pan over a medium heat until just warmed.

02 Meanwhile rub the butter into the flour until it resembles fine breadcrumbs. Add the salt, yeast, and sugar and stir together.

03 Pour the milk over the butter and flour mixture and stir to combine. Using your hands, mix everything until it all comes together to form a soft dough.

04 Flour your work surface and tip out the dough. Knead the dough for 10 minutes or until smooth and elastic. Alternatively, knead the dough in a food processor fitted with a dough hook.

05 Divide the dough in two. Set one half aside and divide the other half in two again. Sprinkle the cinnamon and 1 tsp cocoa powder over one half and the remaining cocoa powder over the other (you may need to adjust the quantities slightly to achieve the desired color). Briefly knead both to combine. You should now have three balls of dough: one uncolored, one light brown, and one dark brown.

06 Divide each ball of dough into 9 to give you 27 balls of dough in total. Set the darker brown and uncolored dough aside. Roll the 9 balls of light brown dough into cylinders approximately the same length as your pan.

07 Roll out the 9 dark brown dough balls into rectangles large enough to cover the light brown dough cylinders (this doesn't need to be precise). Encase the light brown dough in the dark brown dough.

08 Repeat the above process with the uncolored
dough to create 9 dough cylinders. Place 3 of the
dough cylinders into the pan, then add a further
3 and finally the remaining 3. Cover with greased
plastic wrap and leave in a warm place for
approximately 40 minutes or until the dough
has risen almost to the top of the tin. Meanwhile
preheat the oven to 430°F/220°C.

09 Bake for 30 minutes until risen and golden.
Cool in the tin then turn out onto a wire rack.
Slice and serve while still warm, then spread
with hazelnut chocolate spread.

Leopard-print Gelatin

This gelatin looks amazing made in a leopard-shaped mold. However, if you can't find one, a cat-shaped mold is a good substitute—or simply make the gelatin in a serving dish or individual glasses.

1 x 6oz (170g) package	**orange- or lemon-flavored gelatin**
1¾oz (50g)	**milk, dark, and white chocolate buttons or chips**

01 Prepare the gelatin mixture according to the package instructions.

02 Pour approximately one third of the gelatin mixture into the mold.

03 Allow to cool slightly, then refrigerate for 20 minutes or until just set.

04 Cover the surface of the gelatin with approximately half of the chocolate chips, pushing a few into the gelatin as you go, then pour over another third of the gelatin mixture. Return to the refrigerator for a further 20 minutes.

05 Cover the surface of the gelatin with the remaining chocolate, pushing a few into the gelatin as before, then pour over the remaining gelatin and return to the refrigerator until set.

Easy-peasy Leopard Cake Decoration

Turn a simply decorated homemade or store-bought cake into a stunning showstopper with this super-effective technique. Any size or shape of cake will work, as long as it's covered with smooth fondant. You can stick to the traditional black and brown spots here or go wild with any color combination—as long as one color is darker than the other.

1	**cake covered in fondant icing**
2 colors	**gel food coloring**, one darker than the other
	lemon juice (if required)
2	**cake-decorating brushes**

01 Prepare the food coloring as per the package instruction (this may require diluting the gel in lemon juice to achieve the desired color) and place in separate shallow dishes or ramekins.

02 Dip one of the brushes into the lighter-colored gel and paint irregular-shaped circles onto the fondant using a light tapping motion. You may like to cover all of the surface or just the sides or top—whatever takes your fancy. Set the cake aside to allow the gel to dry for a few minutes.

03 Dip the other brush into the darker-colored gel and paint borders around the spots using the same light tapping motion. Don't completely border all of the spots—use letter "C" shapes on some, and perhaps just border the sides or tops and bottoms of other spots.

04 Set the cake aside to allow the gel to dry, then serve your creation.

Leopard-print Glasses

This simple yet oh-so-effective trick can be used to create a leopard-print effect on all manner of glassware. Try decorating jelly jars or mason jars and using them to serve orange-based smoothies or banana milkshakes to really up the leopard rating.

4	**jelly jars or mason jars**
3½oz (100g)	**milk chocolate**
3½oz (100g)	**dark chocolate**
1	**fine paintbrush** (with a handle long enough to reach the bottom of the jars)

01 Melt the milk chocolate in a heatproof bowl over a pan of barely simmering water.

02 Dip the paintbrush into the melted chocolate and paint spots of different shapes and sizes onto the inside of each of the jars. Refrigerate the jars for at least 30 minutes or until the chocolate spots are completely set.

03 Meanwhile melt the dark chocolate in a separate bowl over a pan of barely simmering water, then wash and dry the paintbrush.

04 Remove the jars from the refrigerator. Dip the clean paintbrush into the melted chocolate and paint a ring around each of the milk chocolate spots. Your painting doesn't need to be accurate—a little variation will add to the authenticity!

05 Put the jars in the refrigerator for at least 30 minutes. Meanwhile, make your favorite milkshake or smoothie.

06 Take the jars from the refrigerator, pour in your drinks, add straws, and serve to your leopard-loving guests.

Leopard-print Face Paint

Perfect for Halloween, festivals, or fancy dress, or just because, this stunning face paint will certainly have you standing out from the crowd. For the best effects, decorate a small area of your face such as the temple and cheek area around one eye.

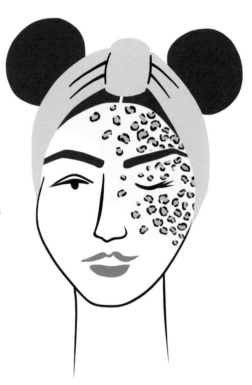

- **gold shimmer eye shadow or face paint**
- **eye shadow brush**
- **brown eye shadow or powder face paint**
- **black gel or liquid eye liner**

01 Cover the skin you are going to decorate with gold shimmer, patting with your finger and blending lightly as you go.

02 Cover the tip of the eye shadow brush with the brown eye shadow or face paint and dot small brown spots over the gold shimmer.

03 Draw an outline around the spots using the black eye liner. Don't completely border all of the spots—use letter "C" shapes on some, and perhaps just border the sides or tops and bottoms of other spots.

04 Stand back and admire your work.

Leopard Nail Art

When it comes to nail art, more is definitely more! Don't be afraid to go for the brightest nail polish you can find here—neon brights outlined in black work particularly well.

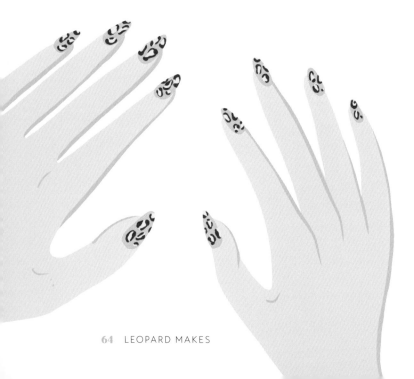

- **light-colored nail polish** for the base coat
- **mid-colored nail polish** for the spots
- **dark-colored nail polish** for outlining
- **toothpicks**
- **old dish or plate**
- **nail polish top coat**

01 Paint your nails using the light-colored base coat and allow to dry completely.

02 Drop a little of the mid-colored polish onto an old dish or plate. Dip one end of a toothpick into the polish and dot spots onto each of your nails. Allow to dry completely.

03 Drop a little of the dark-colored polish onto the dish or plate. Dip one end of the other toothpick into the polish and roughly outline each of the spots, leave some only partially lined. Allow to dry completely.

04 Paint each nail with the top coat to seal your designs.

Leopard-print Hair

Hair decorated with a leopard print is all the rage and is surprisingly simple—all you need is some spray hair color and a stencil. You can either create the stencil yourself by drawing a leopard-print pattern on some stiff cardboard and cutting it out, or you can buy a stencil online. This technique works best on naturally fair or bleached hair.

- **stiff cardboard**
- **pencil**
- **scissors**
- **black spray hair color**
- **brown spray hair color**

01 If you are making the stencil yourself, draw your design on the cardboard using the pencil. To make this look really authentic while keeping it simple, draw a series of different-shaped spots with C-shaped borders. (If you are using a ready-made stencil, skip to Step 3.)

02 Cut out the border patterns, leaving the center of the spots intact.

03 Hold the stencil up against the hair you want to leopardify. If you are creating the design on long hair, hold the hair taut. Take the black spray color and spray through the cut-out sections of the stencil onto the hair to create the borders.

04 Set the stencil aside and again hold the hair taut. Take the brown spray color and, in short bursts, spray brown spots onto the hair to fill in the centers of the black borders.

05 Repeat to cover as much of the hair as you like.

Leopard Lives

Act Like a Leopard

Not exactly the wallflowers of the animal kingdom, leopards are known for being solitary, elusive, and fierce. These beautiful creatures have been a source of fascination for millennia—notoriously difficult to find, let alone photograph, they have always been something of an enigma. As the fashion for wearing leopard print (see page 14) exploded in the 1920s and 1930s, so did our interest in these spotted wild cats.

Graceful yet powerful, stealthy yet ferocious, a leopard's talents are varied and wide-ranging. Preferring to hunt at night and rest during the day, these camouflaged wonders have a reputation for being meticulous predators that are unrelenting and merciless with their prey. This reputation carries over to mythology and literature, where leopards are often depicted as mysterious bloodthirsty animals with great spiritual significance. So what does this say about leopard-print devotees?

Leopard print continues to be one of the most widely sold animal prints in the fashion world, from fast-fashion pieces to high-end glamour. Enduring, timeless, and eye-catching, it has been said that anyone can wear leopard. So wear your spots with pride and read on for a dip into the wonderful world of this fascinating feline.

Heard the one about the strawberry-colored leopard?

In 2012 a rare strawberry-colored leopard was photographed in the Madikwe Game Reserve in South Africa. It's thought that the leopard's pink hue is caused by erythrism, a genetic condition that causes an overproduction of red pigmentation.

DID
YOU
KNOW
...?

Leopards are built for hunting

Their sleek, powerful bodies and stealth-like movements make leopards formidable predators, giving their preferred prey of gazelle, impala, deer, and wildebeest little chance of escape. Their impressive strength also allows leopards to drag their prey high up into the trees to protect it from scavengers.

The Magic of Snow Leopards

Known as the "gray ghosts of the mountains," snow leopards are thought to hold the answers to the mysteries of life and death. These fascinating creatures are found in the high rugged mountains of central Asia, from southern Russia to the Tibetan plateau, including Mongolia, China, Afghanistan, Pakistan, India, and Nepal. Rarely seen, they are perhaps the least understood of all eight leopard sub-species and their existence is shrouded in mystery.

It is said that the elegant snow leopard has the ability to remove people's sins from past lives. However, if a snow leopard is killed, the sins of the killer's past life will be transferred to the present. They are thought to be close to shamans, with magical, otherworldly powers. Their population is sadly dwindling, but if you are ever lucky enough to spot a snow leopard, be sure to treat it with respect to avoid being landed with the sins of your past lives.

"And the beast which I saw was like unto a leopard, and his feet were as the feet of a bear, and his mouth as the mouth of a lion: and the dragon gave him his power, and his seat, and great authority."

—Revelation 13:2
KING JAMES BIBLE

"Can the Ethiopian
change his skin,

or the leopard his spots?

Then may ye also
do good,

that are accustomed
to do evil."

—Jeremiah 13:23
KING JAMES BIBLE

Leopards in Literature

"I'll take spots, then," said the Leopard, "but don't make 'em too vulgar-big. I wouldn't look like Giraffe—not for ever so."

—How the Leopard Got His Spots
IN JUST SO STORIES BY RUDYARD KIPLING

King Richard II: "...lions make leopards tame."

Thomas Mowbray: "Yea, but not change his spots."

—Richard II
WILLIAM SHAKESPEARE

"That night a little son was born in the tiny cabin beside the primeval forest, while a leopard screamed before the door, and the deep notes of a lion's roar sounded from beyond the ridge."

—Tarzan of the Apes
EDGAR RICE BURROUGHS

"I hate to tell you this," Jason said, "but I think your leopard just ate a goddess."

—The Lost Hero
RICK RIORDAN

"A leopard does not change his spots, or change his feeling that spots are rather a credit."

—More Women than Men
IVY COMPTON-BURNETT

"We were the Leopards,
the Lions; those who'll take
our place will be little jackals,
hyenas; and the whole lot
of us, Leopards, jackals,
and sheep, we'll all go on
thinking ourselves the
salt of the earth."

—The Leopard
GIUSEPPE TOMASI DI LAMPEDUSA

"A black shadow dropped down into the circle. It was Bagheera the Black Panther, inky black all over, but with the panther markings showing up in certain lights like the pattern of watered silk. Everybody knew Bagheera, and nobody cared to cross his path, for he was as cunning as Tabaqui, as bold as the wild buffalo, and as reckless as the wounded elephant. But he had a voice as soft as wild honey dripping from a tree, and a skin softer than down."

—The Jungle Book
RUDYARD KIPLING

A leopard's spots are actually for camouflage

The leopard's spots, so noticeable when the print is worn by humans, are actually an evolutionary adaptation that allows leopards to remain camouflaged in their natural environment when they hunt.

"There are tame animals and wild animals.

Man and the mule are always tame;

the leopard and the wolf are invariably wild..."

Aristotle

"In the third month, the sun rising, the Boar and the Leopard on the field of Mars to fight; The tired Leopard raises its eye to the heavens, sees an eagle playing around the sun."

Nostradamus

Leap

by name,

leap

by nature

The collective noun for a group of leopards is a leap, which is particularly suitable as leopards are pretty good at leaping and can travel up to 20ft (6m) in one bound.

Leopards are nocturnal

Leopards spend their days resting, camouflaged by trees or hiding in caves. Night-time is a different story—this is when they become very active and go hunting for food.

"Leopards, that is ordinary forest leopards, do not like rain and invariably seek shelter, but the man eater was not an ordinary leopard, and there was no knowing what his likes or dislikes were, or what he might or might not do."

—The Man-Eating Leopard of Rudraprayag
JIM CORBETT

"When you patiently examine the beautiful skin of the leopard after its hard day's search for the meat it enjoys, you shall not only see the sweat that went into its search for the meat, but you shall also realize the scent of the sweat beneath the beautiful skin."

Ernest Agyemang Yeboah
AUTHOR

DID
YOU
KNOW
...?

Leopards are really good listeners

A leopard's hearing is up to five times better than a human's, and its night vision is up to seven times better.

Eyes wide shut

Leopards are born with their eyes shut to protect them against harsh sunlight and to prevent cubs from wandering away from their mothers. Their eyes usually open around two weeks after birth.

DID YOU KNOW ...?

Leopards can purr and cough

Much like domestic cats, leopards purr when they are happy and relaxed. However, when a male leopard wants to make another male aware of his presence, he'll make a hoarse coughing sound.

Pardon me?

Leopards were once thought to be the offspring of a lioness and a male pard—a bloodthirsty mythological creature with the power of a dragon. It wasn't until the mid-sixteenth century that biologists categorized leopards as a unique species.

Dreaming of Leopards

Dreaming of a leopard or leopards may mean that you are facing obstacles and challenges. It can also signify success and overcoming adversity. A leopard cannot change its spots, and an appearance by this wild cat in your nocturnal dreamland may mean that you are frustrated by your inability to change.

Leopards running freely:
you are facing a challenge and are
determined to succeed at any cost.

Being chased by a leopard:
you are running from difficulties
rather than facing them.

Playing with a leopard:
you have recently conquered a fear or phobia.

Fighting with a leopard:
you are bravely facing your problems and enemies.

Killing a leopard:
you are on the verge of success.

Being killed by a leopard:
you may have to surrender to
your current problems.

Being attacked by a leopard:
major problems or issues are on the horizon.

The Leopard That Lost Its Spots

It's a little-known fact that not all leopards have spots. Black leopards—or black panthers, as they are sometimes known—have a condition called melanism. This causes the body to produce an excess of pigment, making their fur appear black. Black leopards have been spotted in and around Kenya for decades, but until recently the only photograph in existence was one that had been taken in 1909 in Addis Ababa, Ethiopia.

A leopard is half tail

A leopard's tail is typically the same length as its body, aiding balance and allowing for sharp, quick turns.

"When rain falls on a leopard, it wets him

– AFRICAN PROVERB

but does not wash off his spots."

Leopard or not?

Take the quiz below to find out how well you really know your spots.

1. Which animal has evenly spaced solid black dots on a golden-brown background?

a. Leopard

b. Cheetah

c. Jaguar

2. Leopards always have dark "rosette" spots made of thick-edged circles with a lighter-colored center.

True or false?

3. Which of the following exists?

a. Strawberry leopard

b. Raspberry leopard

c. Chocolate leopard

Answers

1. b. Cheetah **2.** False. Black leopards (see page 96) appear to be completely black. **3.** a. Strawberry leopard (see page 70)

Leopard Fun

Play Like a Leopard

Probably the most contradictory of designs, leopard print can be whatever the wearer wants it to be—its spots can take you effortlessly from boardroom to bar, making leopard print the ultimate daywear-to-playwear essential. Enduring and evolutionary, the leopard look hasn't strayed far from the runways and fashion stores for decades, and it is often worn by royalty and rock stars in the same season—quite an accolade.

In recent years, leopard has leapt out of our wardrobes and is causing quite a stir. From laptops to cell phones, cars, doggy daywear, and fun feline articles, a whole host of items are available to glam up our lives, homes, and pets. Spots are taking over the world.

Fancy a little leopard luxury? Adorn yourself with a pure silk leopard-print robe. Want your wheels to purr like a leopard? No problem, there's a leopard-print paint job out there for you. Utterly roarsome. And for total obsessives who want to live the leopard life 24/7, why not go the whole hog and kit out your home leopard-style—from couches to wallpaper, kitchenware to flooring, it really is possible to go totally leopard from dawn till dusk.

Bold, bohemian, and a little bit bonkers, leopard print is nothing if not fun. Read on for funky facts, quirky quotes, and a whole load of spots.

"As far as I'm concerned,

Jenna Lyons
FASHION DESIGNER

leopard is a neutral."

"The message of a
leopard-print jumpsuit
is clear, 'I am a huntress
who delights in eating the
offal of her prey.'"

—*Eccentric Glamour: Creating an
Insanely More Fabulous You*
SIMON DOONAN

Must-have Leopard Print

Own a leopard-print coat? You're most definitely not alone, and chances are your mother and grandmother owned one too—your own child may even borrow yours one day. The most classic of all leopard-print items, the coat has been the stalwart of the fashionable ladies' (and gents') wardrobe since the 1930s; historically it is the most frequently sold leopard-print item of all. From high-end designer treat to thrift-shop trawl, there's a leopard-print coat for every budget, age, and occasion. If you don't already own one, what are you waiting for?

#leopard

To date, the hashtag
"leopard" has been applied
to around 5 million posts
on Instagram. That's a whole
lot of leopard lovers.

Banned Leopard

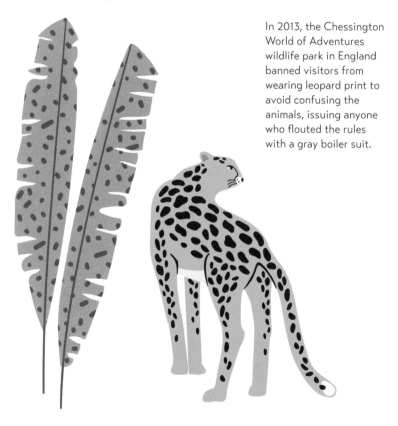

In 2013, the Chessington World of Adventures wildlife park in England banned visitors from wearing leopard print to avoid confusing the animals, issuing anyone who flouted the rules with a gray boiler suit.

Heard about the leopard-print opera house?

Opera and leopard print may not seem an obvious pairing, but directors at the Sydney Opera House are clearly fans—in 2013, a leopard-print pattern was projected onto the building's iconic sails.

Celebrities Love Leopard

When asked what she would choose if she could only wear one print for the rest of her life, model Kate Moss replied: "Might be the leopard. But I'm sure that comes as no surprise". Kate has been photographed wearing leopard print more than any other celebrity, and for good reason—she looks amazing in it. Such is her love for the design that she even made it the signature pattern of her range for French clothing label Equipment.

We've all heard of celebrities making crazy demands in their riders, and singer Rihanna likes to keep it wild before she performs. The star is said to request that a large, plush throw rug in cheetah or leopard print is placed in her dressing room for her to walk on barefoot (the rider specifies that the rug must be clean). Rihanna was also photographed wearing a daring see-through leopard-print catsuit by *Interview* magazine in 2019, showing unwavering dedication to the feline fashion.

But it's not only models and celebrities who like to step out in leopard print. Back in 1952 the Queen was photographed leaving Buckingham Palace wearing a leopard-print coat, and many royals followed suit. Princess Diana caused quite a stir in 1990 when she modeled a matching leopard-print swimming costume and skirt ensemble in the Virgin Islands, and the Duchess of Cambridge looked fierce in a leopard-print maternity dress on a visit to an art gallery in 2015.

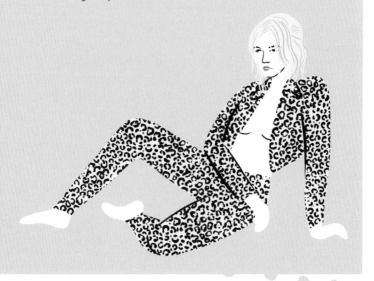

When Is a Leopard Not a Leopard?

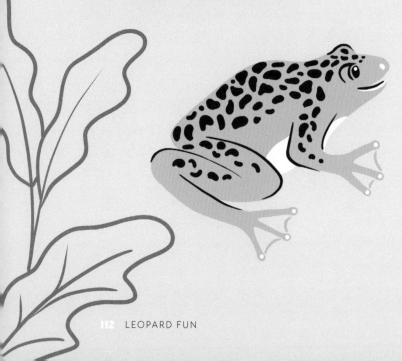

When it's a frog! Or a fish. Or a moth... So effective are the leopard's spots at camouflaging the great cat that, unsurprisingly, other species in the animal kingdom have also evolved to take advantage of the same coloring to conceal themselves. Native to North America, the leopard frog gets its name from its distinctive spotted coloring, enabling it to blend into its marshy surroundings; the African leopard bush fish lives up to its name as a fierce predator likely to devour anything in its path; and the giant leopard moth uses its spots to make itself less conspicuous to predators.

"My mother was very good at encouraging me to dress however I wanted to dress. My sisters would sometimes think, 'Oh my God, you let her buy that fuzzy leopard coat at that vintage store?' I thought, of course, I looked like Audrey Hepburn."

Kate Spade
FASHION DESIGNER

"My weakness
is wearing

too much
leopard print."

Jackie Collins
NOVELIST

Why can't a
leopard hide?

*Because he's
always
spotted.*

Why can you always
trust a leopard?

*Because it's
not a cheetah.*

Which side of a leopard
has more spots?

The outside.

How does a leopard
change its spots?

*When it gets
tired of one spot
it just moves to
another.*

A bland young hunter
named Shepherd

was eaten for lunch
by a leopard.

Said the leopard, "Egad!

You'd be tastier, lad,

if you had been
salted and peppered!"

ANONYMOUS

The Leopard Man

One man who took his love of leopard print to new heights was Tom Leppard (not his real last name). Tom had a leopard-print pattern tattooed over 99.9 percent of his body—all but the insides of his ears, his chin, and in between his toes was covered with leopard spots. Even his eyelids were tattooed to resemble a feline's blue-green irises, and to complete the look, Tom had a set of fangs custom-made by a dentist.

In 2001 Tom was listed in the Guinness Book of Records as the most tattooed man on earth, and until the latter part of his life he chose to live in relative isolation on the Scottish island of Skye, in a remote "cave" built on the foundations of a ruined croft. A true leopard-lover indeed.

The Leopard-print House

Believe it or not, it does exist. In the Rogers Park district of Chicago sits the ultimate home for leopard lovers—a house painted with leopard spots. Owner Michael Riley admits that the print wasn't his first choice of paint job, but when six friends moved into the house in 2002 it was the only style they all agreed on. Today the house has been split into apartments and can be rented by lucky leopard fans.

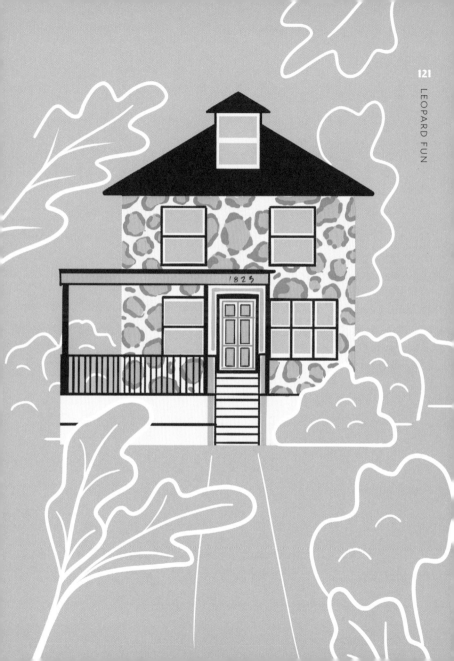

Leopard Sellout

Hailed as the most viral clothing piece of the year, 2018 saw leopard lovers everywhere go wild for Réalisation Par's "Naomi" skirt. This slinky knee-length leopard-print number was by far the most blogged-about skirt of the season.

The "it" scarf

Who knew a scarf would grace quite so many fashion pages? In the early 2000s the outdated pashmina was given a much-needed revamp thanks to fashion designer Steven Sprouse who created a leopard-print scarf for Louis Vuitton. And it created quite a frenzy. Pretty soon every celeb and fashionista worth their column inches was photographed wearing the scarf in various hues, and copies sprung up in every shopping mall. It graced the necks of everyone from Sarah Jessica Parker to Kate Moss; Beyoncé even found a new purpose for hers by using it to protect a newborn Blue Ivy from prying paparazzi.

As testament to the scarf's success and in tribute to the designer, who sadly passed away before he was able to see how iconic his design has become, Louis Vuitton are still selling an updated version of Steven Sprouse's original for a cool $730.

"I don't know why, but I've always been into leopard print. No joke, when I was 14 years old I wanted my entire room to be covered in it... I think maybe my obsession had something to do with my grandmother—she told me the best print to buy is leopard because it always stays in style."

Khloé Kardashian
REALITY TV STAR

"In each of my homes,
I have a leopard room.
I don't know why,
but I do. It's like my
lounge next to the
dressing rooms."

Ivana Trump
BUSINESSWOMAN AND FORMER MODEL

Sheena: Queen of the Jungle

The original leopard-print-loving comic book heroine Sheena, Queen of the Jungle, was created in 1937 by Will Eisner and Jerry Iger. A small girl who is raised by an African tribe after her parents are killed while on safari, Sheena learns to communicate with wild animals and defend herself against predators. The leopard-skin-clad Sheena was such a hit that the comics were adapted for the small screen in the mid-1950s and again in the early 2000s, and in 1984 *Sheena* the movie hit cinemas.

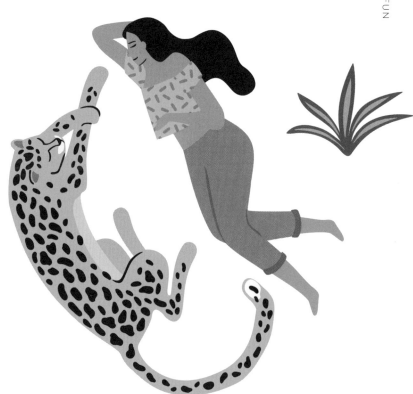

Published in the United Kingdom by HarperCollins in 2020.

I Love Leopard. Copyright © HarperCollins Publishers 2020.

Text by Emma Bastow.
Illustrations by Abi Read
and Shutterstock.
Design by Abi Read.

HarperCollins books may be purchased for
educational, business, or sales promotional use.
For information please email the Special Markets
Department at SPsales@harpercollins.com.

Published in 2020 by Harper Design
An Imprint of HarperCollinsPublishers
195 Broadway
New York, NY 10007
Tel: (212) 207-7000
Fax: (855)746-6023
harperdesign@harpercollins.com
www.hc.com

Distributed throughout the world by
HarperCollins Publishers
195 Broadway
New York, NY 10007

ISBN 978-0-06-302588-2

Library of Congress Cataloging-in-Publication Data has been applied for.

Printed and bound in Latvia by PNB Print Ltd.

First Printing, 2020.